'I haven't clawed my way to the top
of the food chain just to eat vegetables.'
charles jarvis

AND SO I FACE THE
VINYL CURTAIN...

Drawings and Verses
by Simon Drew

MICHELANGELO'S DVD

ANTIQUE COLLECTORS' CLUB

to Caroline

a problem shared is gossip

©2005 Simon Drew
World copyright reserved

ISBN 1 905377 01 0

British Library Cataloguing-in-Publication Data
A catalogue record for this book is available from the British Library

Printed in China
for the Antique Collectors' Club Ltd., Woodbridge, Suffolk

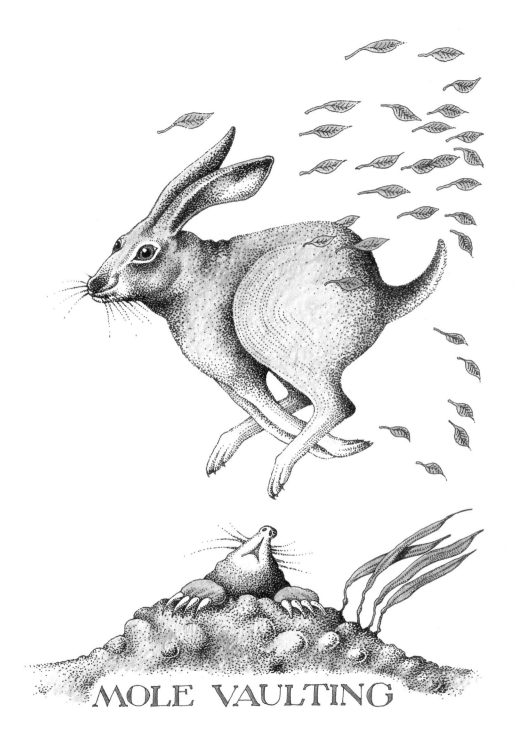

MOLE VAULTING

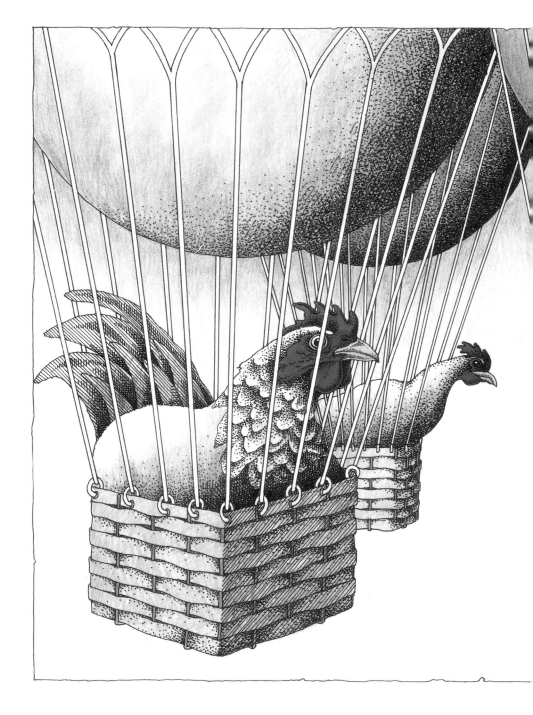

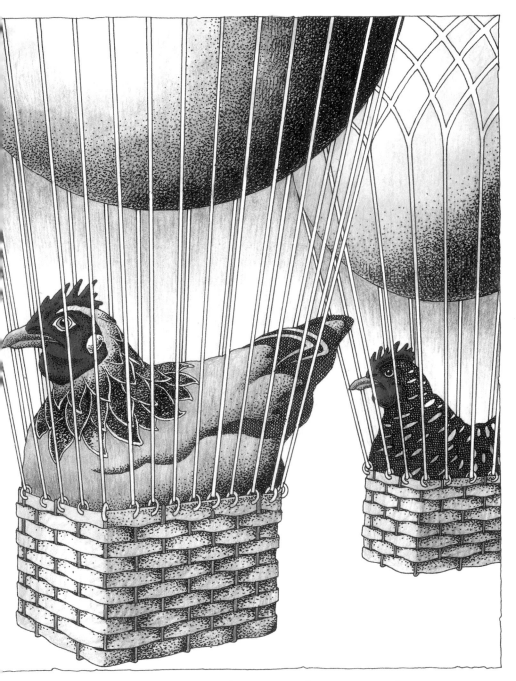

chicken in the basket

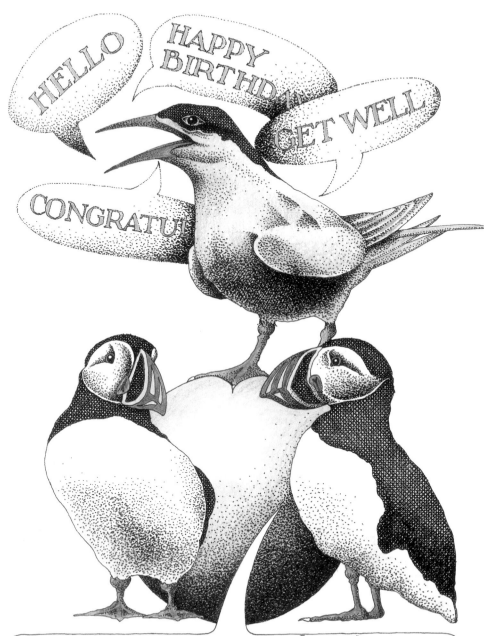

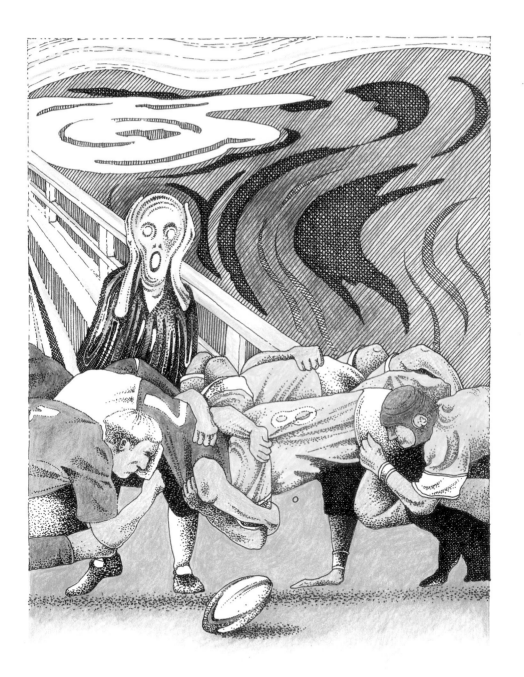

Munch's "The Scrum"

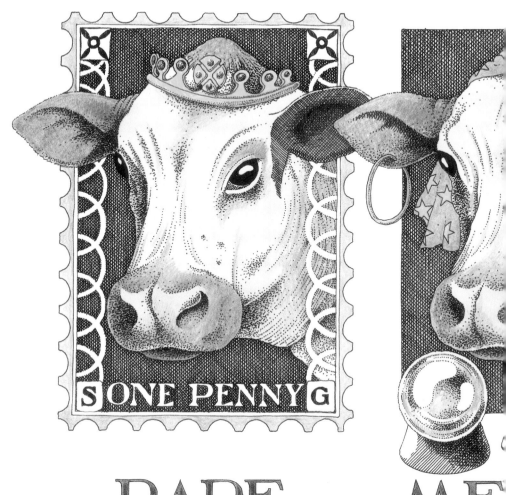

ONE PENNY

RARE
BEEF

ME
BE

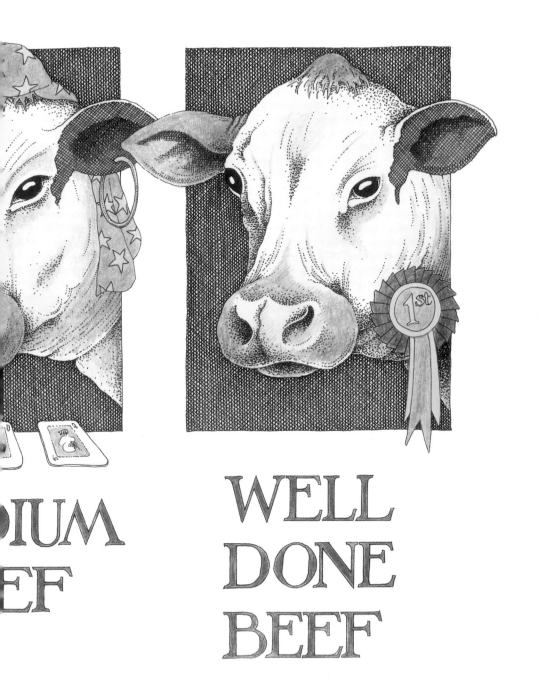

DIUM
EF

WELL
DONE
BEEF

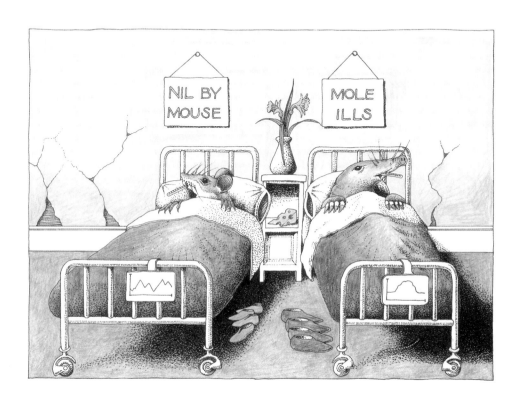

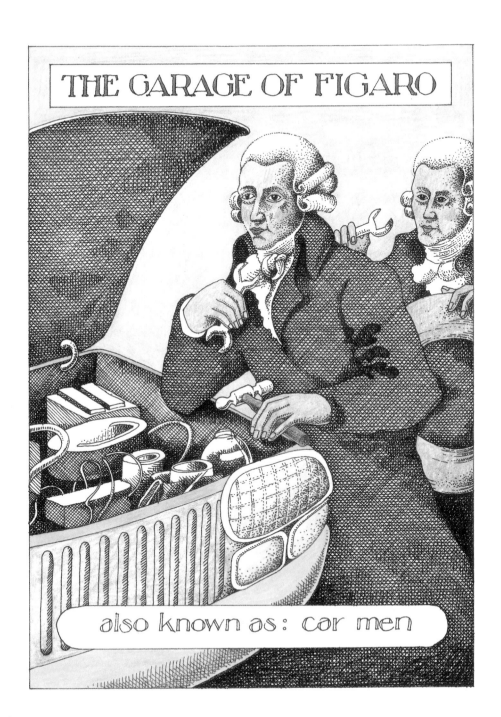

THE GARAGE OF FIGARO

also known as: car men

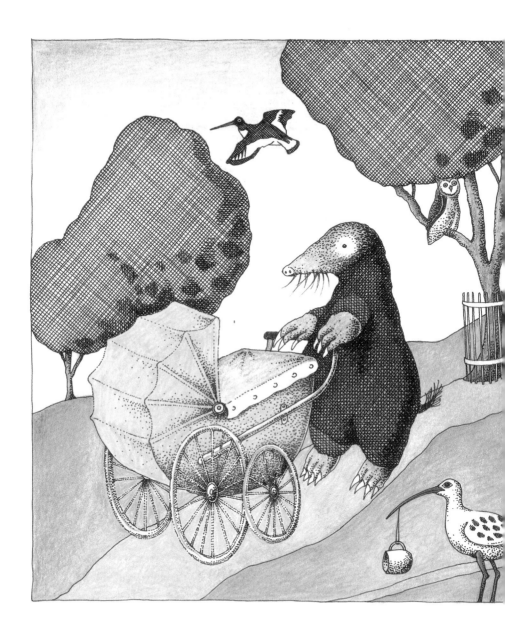

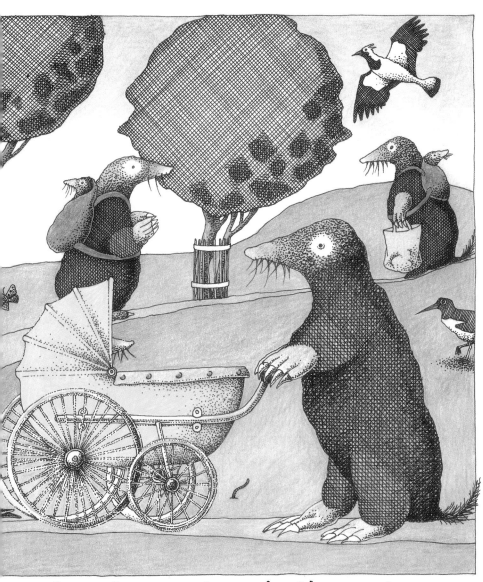

See the mothers in the park:
they're rather ugly, chiefly.
Someone must have loved them once
but in the dark, and briefly.

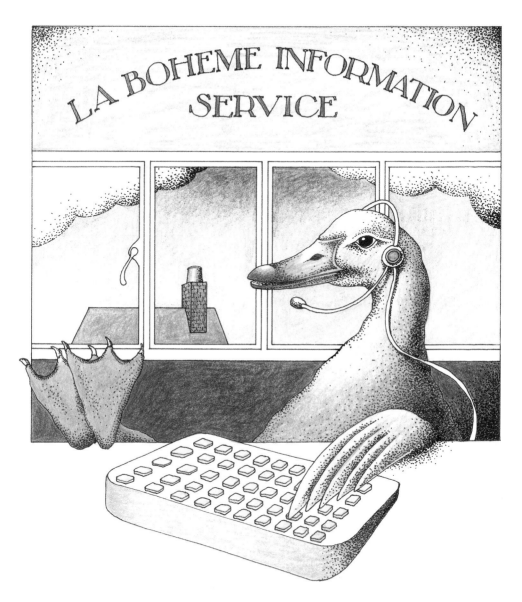

Your call is very important to us
but all our opera haters are
busy at the moment

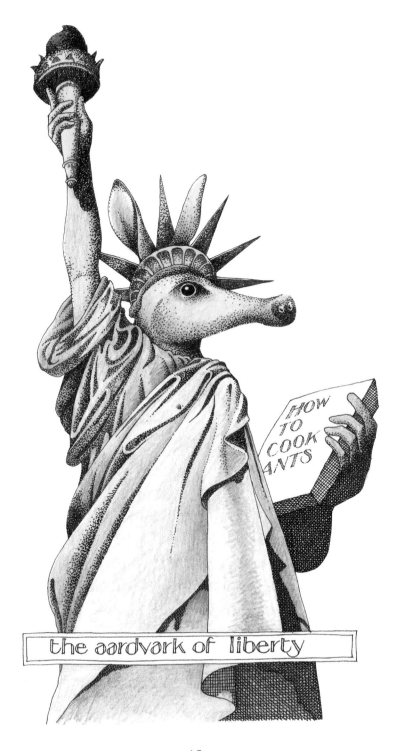

the aardvark of liberty

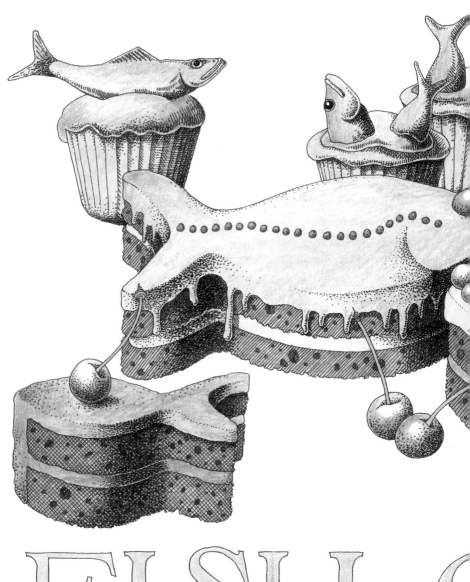

FISH C

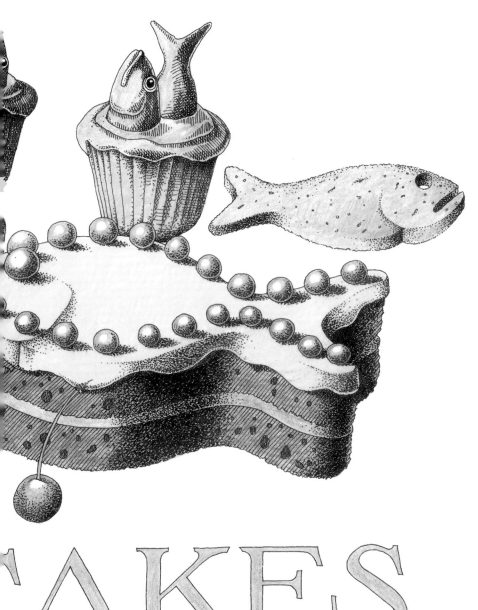

CAKES

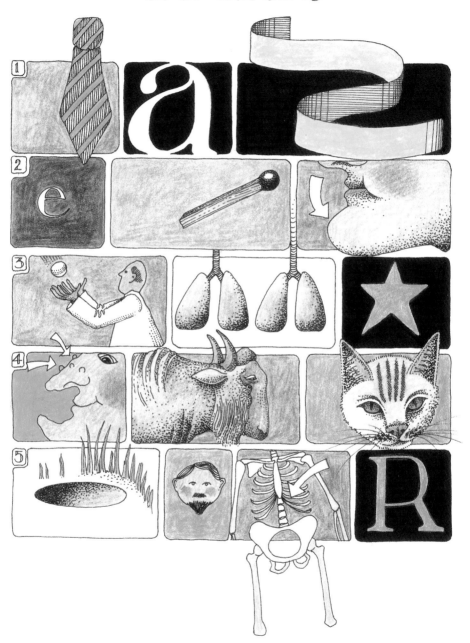

SPOT THE SONG

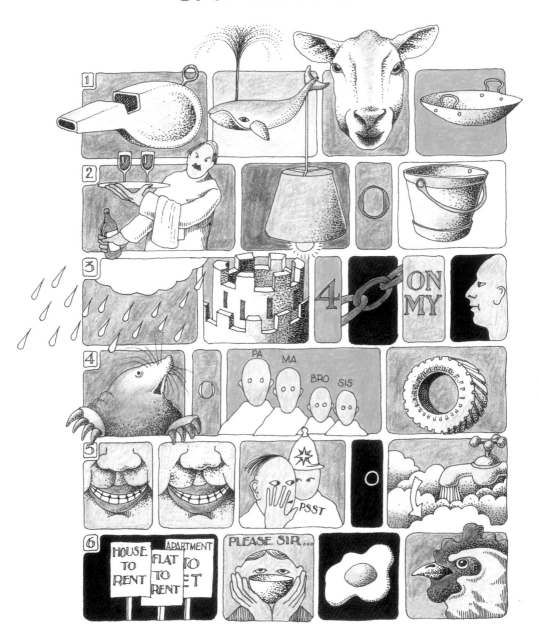

SPOT THE NURSERY RHYME

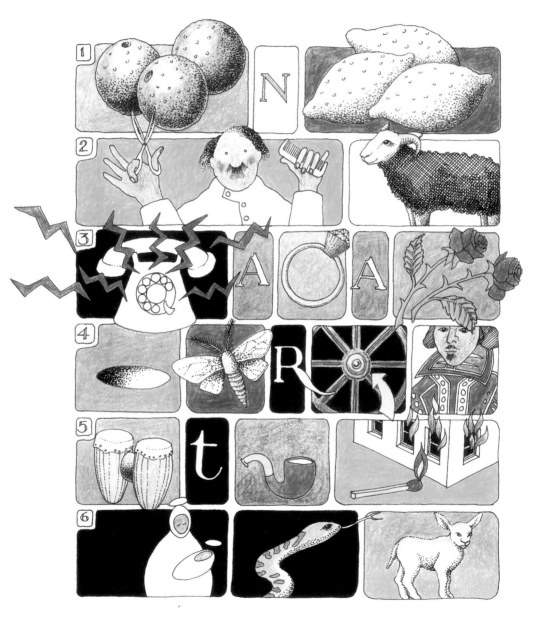

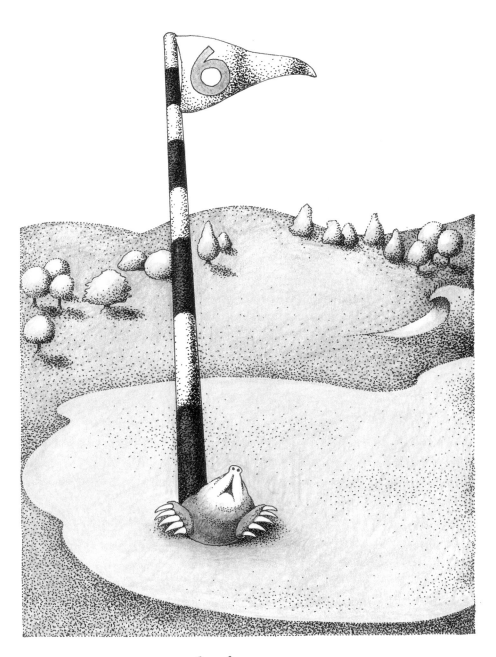

mole in one

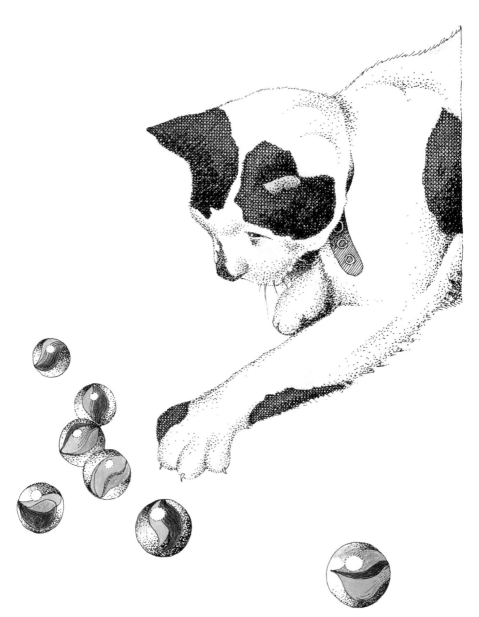

Elgin's cat playing with his marbles

important vegetables in history:

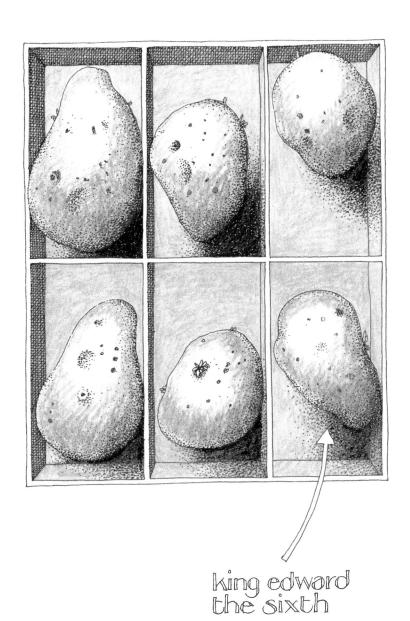

king edward
the sixth

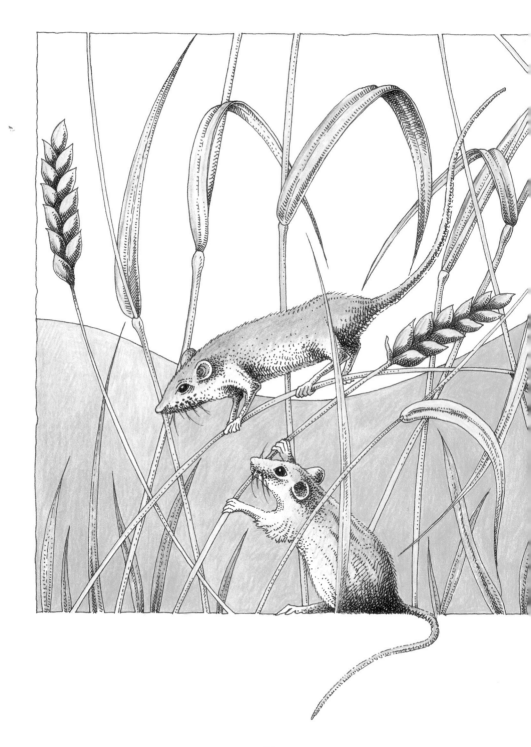

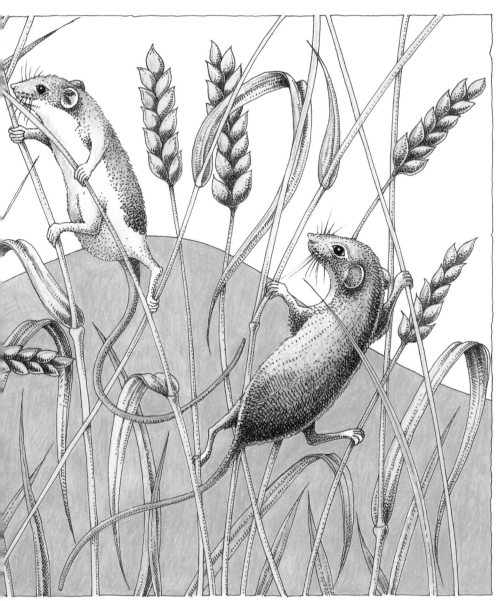

All around us dangers wait,
worse than any thriller:
somewhere hidden in a field
there lurks a cereal killer.

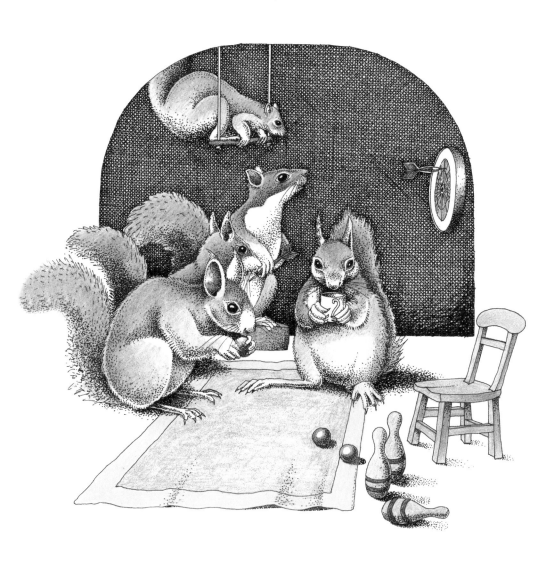

..... suddenly, in a cave, they
discovered the dead sea squirrels.

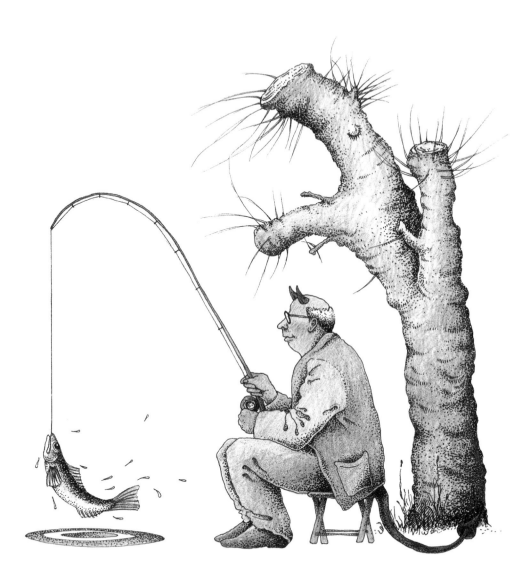

hell's angler

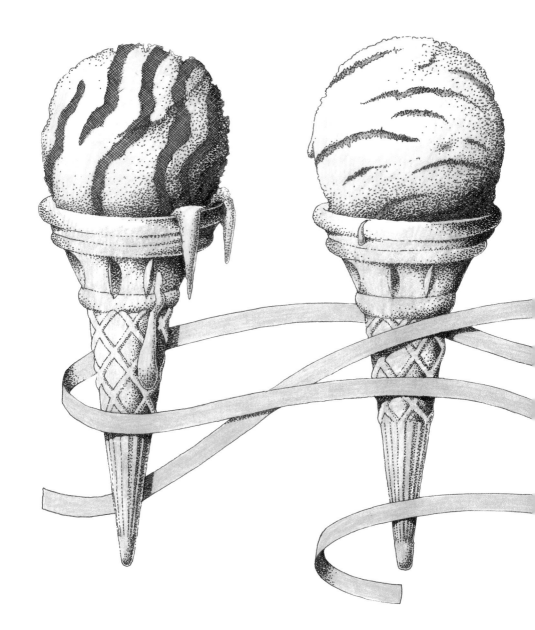

STILL LIFE WITH

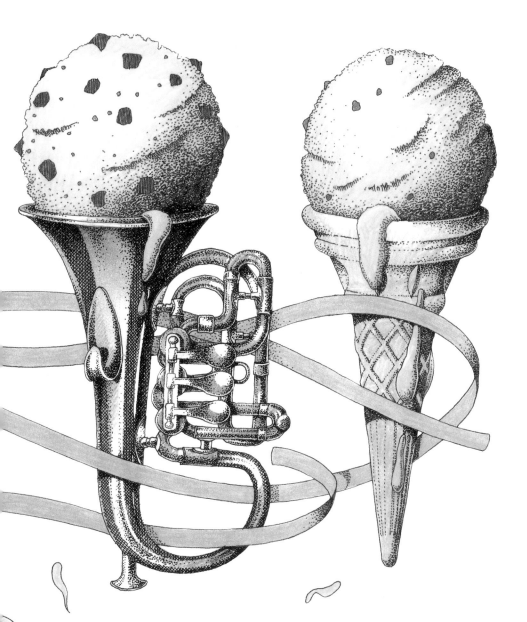

CORNETS......

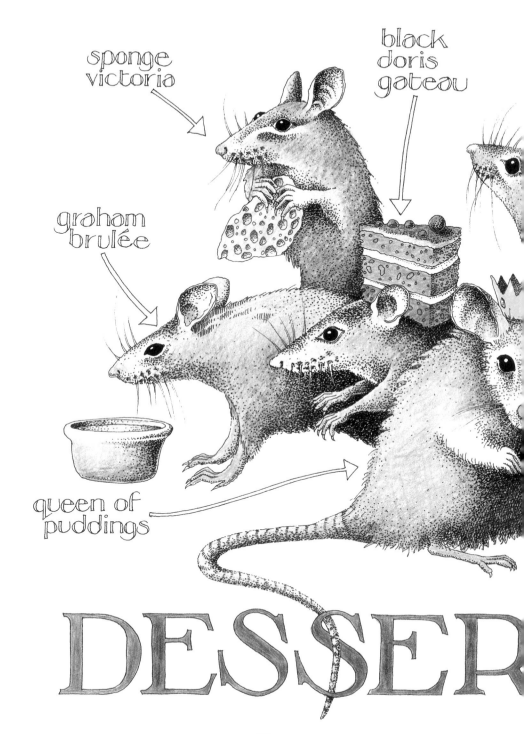

sponge
victoria

black
doris
gateau

graham
brulée

queen of
puddings

DESSER

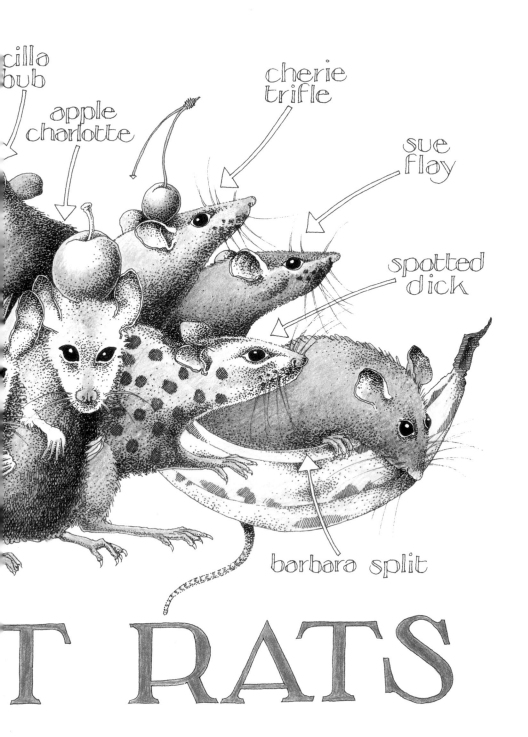

cilla
bub

apple
charlotte

cherie
trifle

sue
flay

spotted
dick

barbara split

T RATS

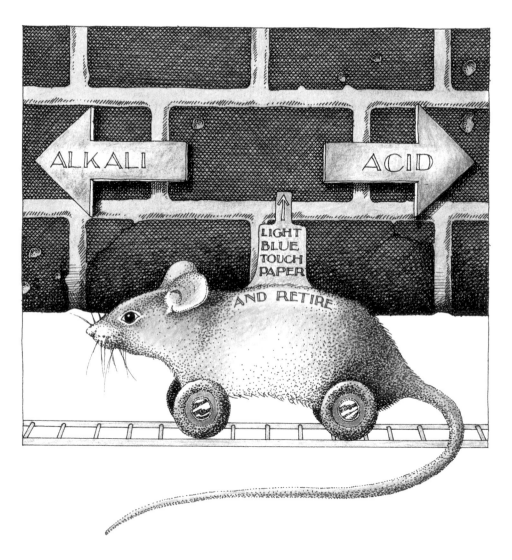

the lit-mouse test

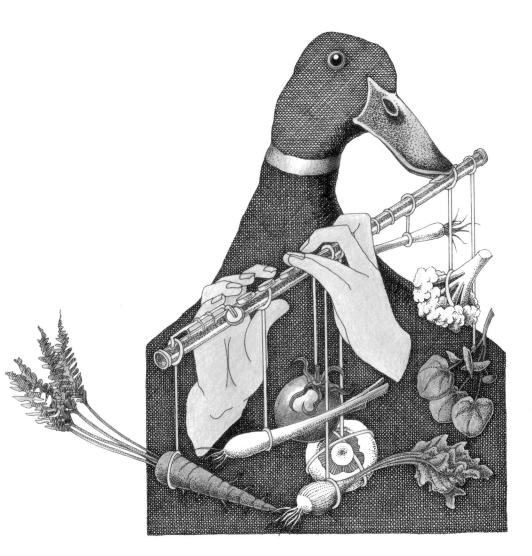

flute salad
(with a little duck)

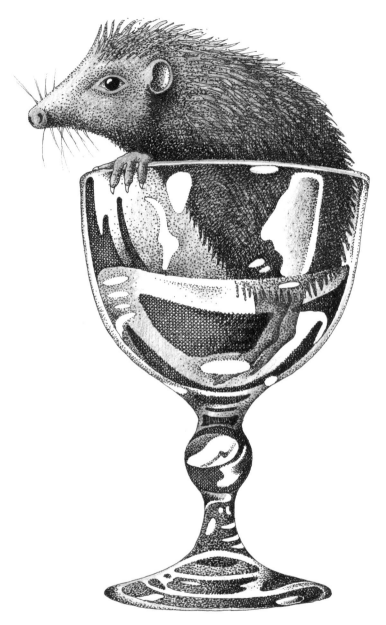

If I had all the money I've spent on drink, I'd spend it on drink.

vivian stanshall

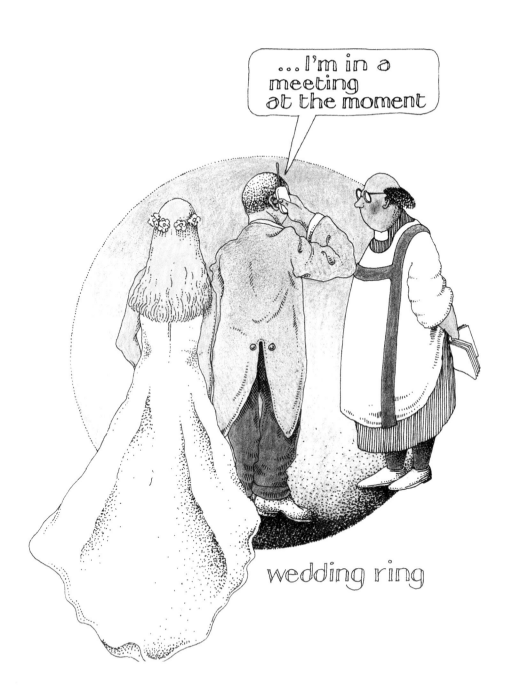

wedding ring

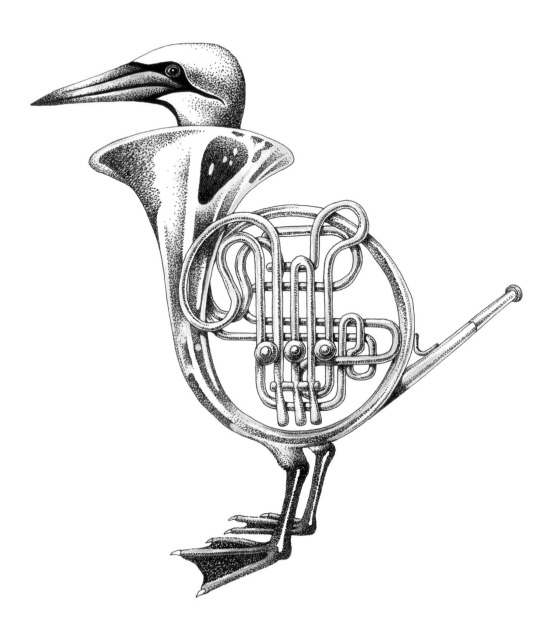

HORNITHOLOGY

SALVADOR deli

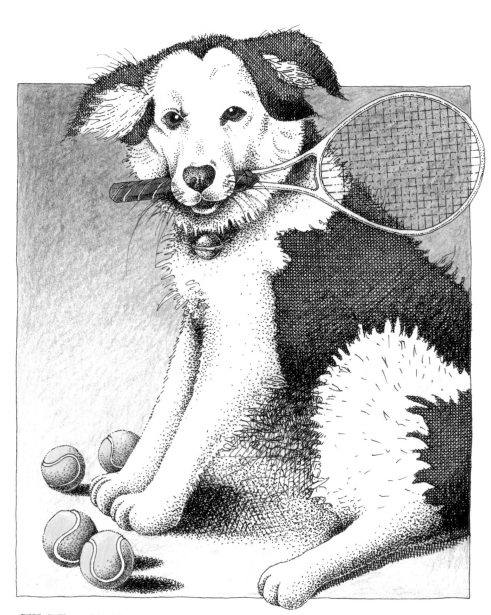

WIMBLEDOG

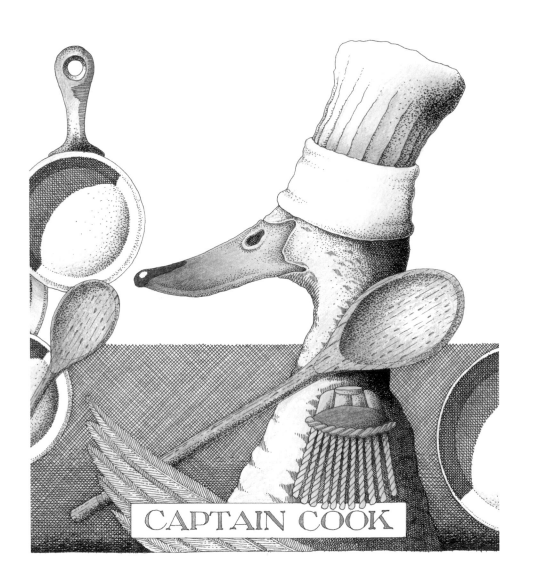

CAPTAIN COOK

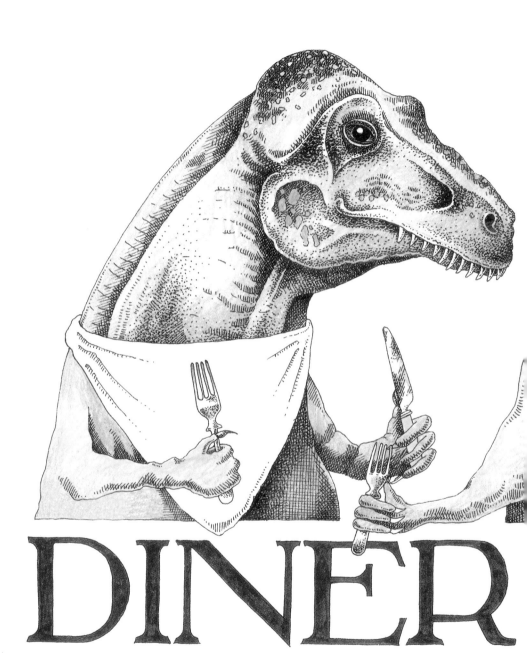

DINER

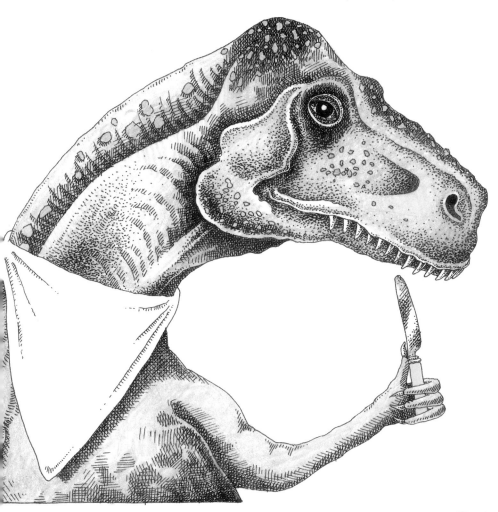

SAURS

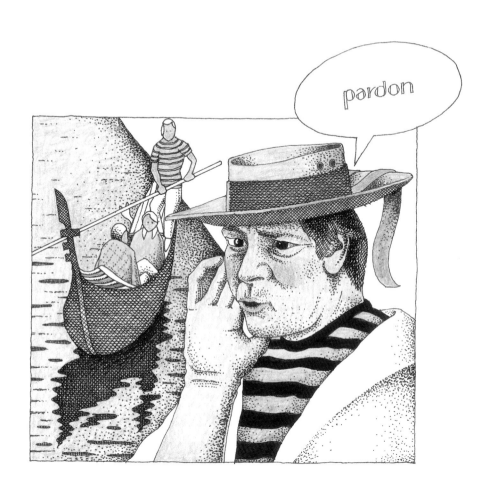

deaf in venice

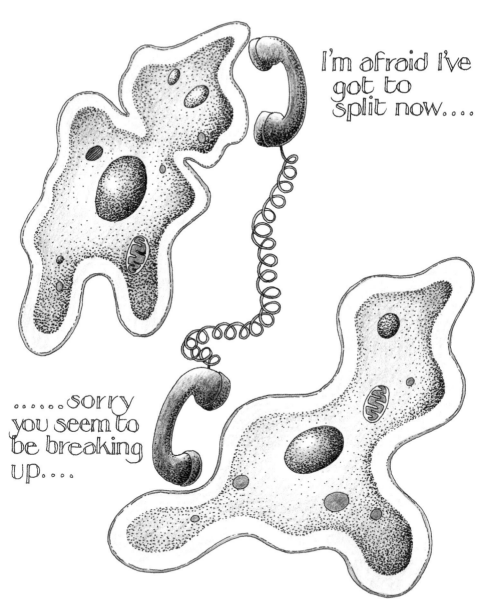

CELL PHONES

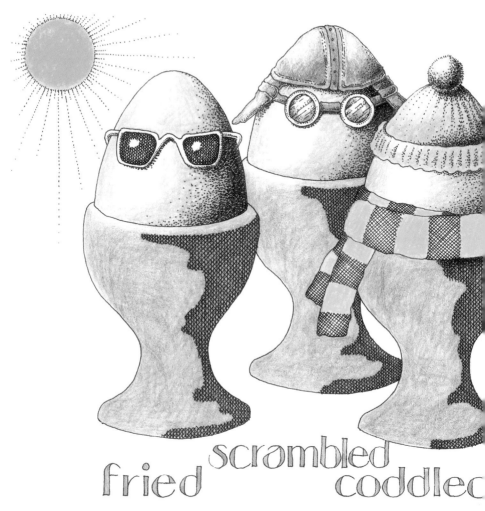

fried scrambled
 coddled

FREE R

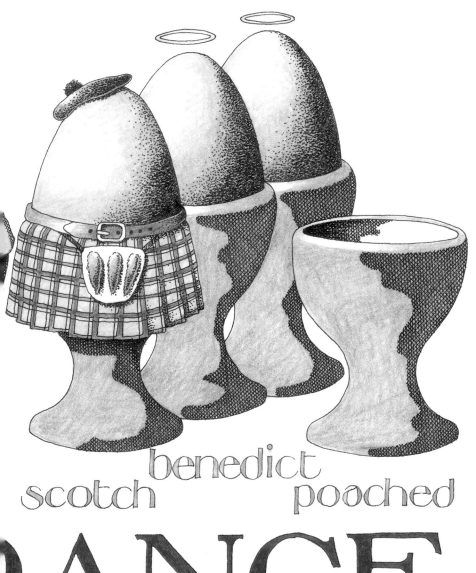

scotch benedict pooched

RANGE

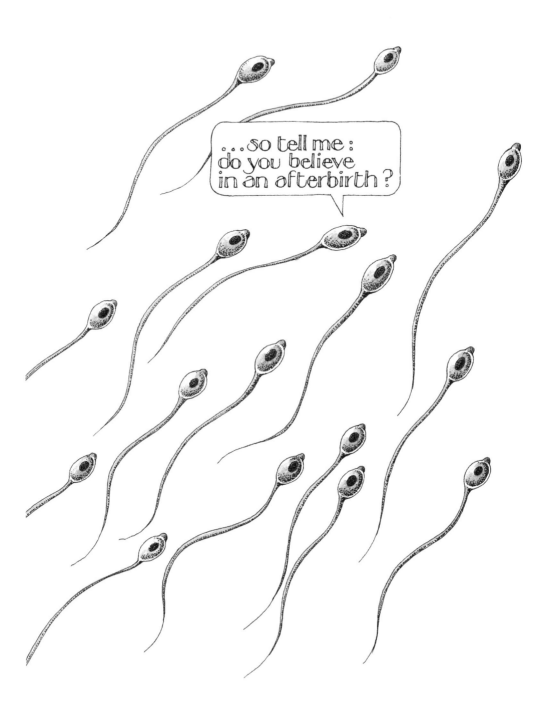

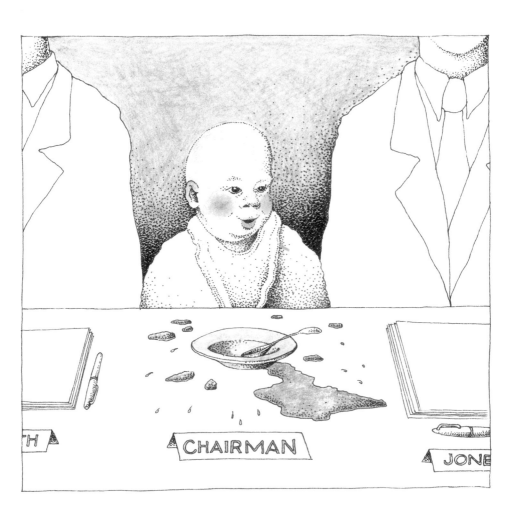

baby on board

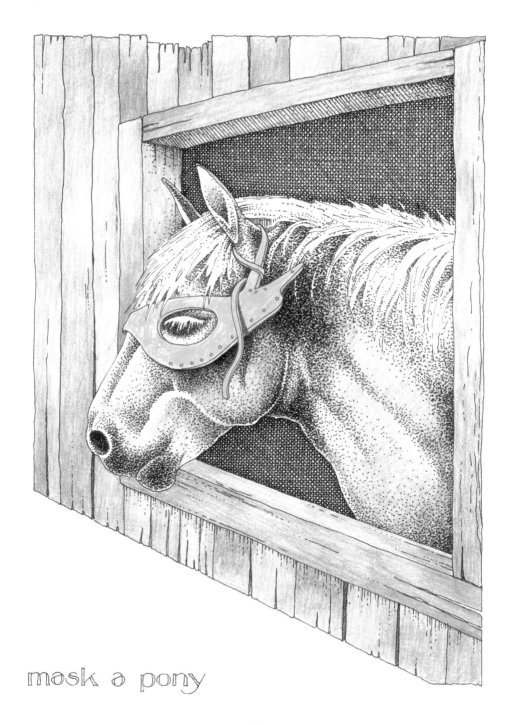

mask a pony

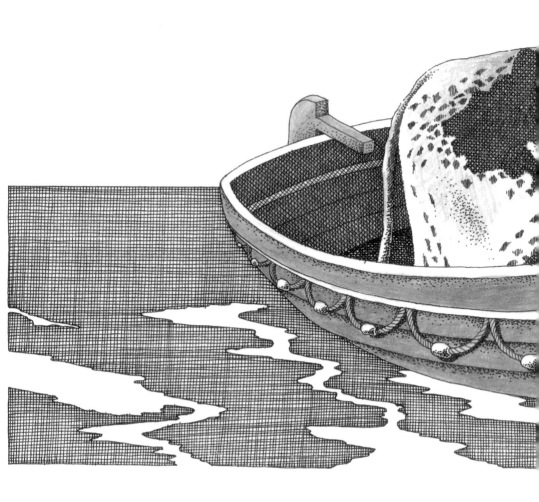